Sold exclusively at Empire State Building.

© 2008 Designed and Published by Terrell Creative
P.O. Box 34260
Kansas City, MO 64120

Designed in USA
Printed in China • 07L0174

ISBN-13: 978-1-56944-369-9
ISBN-10: 1-56944-369-6

Photography collection, Miriam and Ira D. Wallach Division of Arts, Prints and Photographs,
The New York Public Library, Astor, Lenox and Tilden Foundations:
Front Cover, page 4, 5, 6, 7, 8, 9, 10, 12, 16, 17, 19, 26, 27, 30, 40, 48

Avery Architectural and Fine Arts Library, Columbia University in the City of New York:
Page 1, 11, 13, 14, 15, 18, 20, 21, 22, 23, 24, 25, 28, 29, 31, 32, 33, 34, 35, 36, 37, 38, 39, 41, 42, 43, 44, 45, 46, 47

Back Cover and Page 3: Photo © The Estate of Sol Libsohn

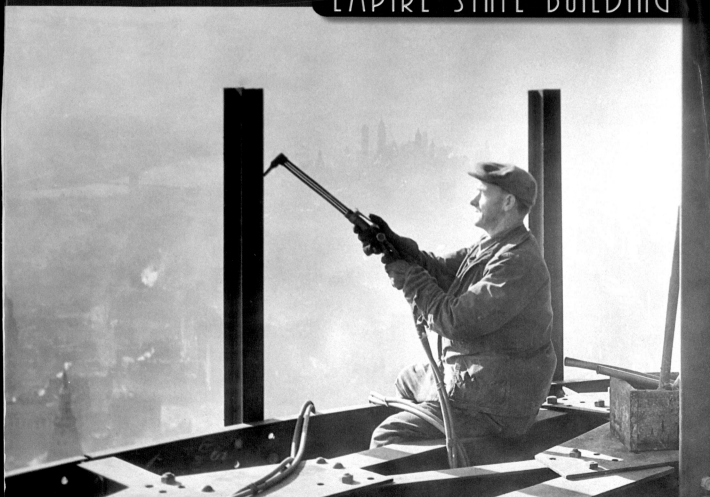

LEWIS
HINE'S
EMPIRE STATE BUILDING

Lewis Wickes Hine (September 26, 1874 - November 3, 1940) was a pioneer in the art of photojournalism. Born in Oshkosh, Wisconsin, and left fatherless at age eighteen, he began his adult life in the study of sociology at the University of Chicago, Columbia University and New York University from 1900-1907. He started his career as a teacher of sociology in New York City at the Ethical Culture School. He began using his camera as a tool to document social conditions, later realizing photography was his true calling.

In 1908, Hine was hired by The National Child Labor Committee to document the working conditions of child laborers. His photographs were instrumental in bringing about new child labor laws, and safety laws for all workers.

During World War I, he photographed the American Red Cross relief work in Europe. In the 1920s and 30s, as machines became more a part of the worker's life, he was keen to record the relationship between man and machinery.

It was because of this background that Hine was commissioned to document the construction of the Empire State Building in 1930. Working alongside the workers, Hine photographed the monumental task of erecting the world's tallest building, while exposed to the same risks and conditions of the workers. Keep in mind, as you view the historic photographs that follow, where Hine must have been "standing" at the time. It is also important to remember the size and weight of cameras in 1930. These photographs are truly a masterful collection of art that should be cherished by all generations to come.

Throughout his life Lewis Hine sought to bring about social change through his photographs. He leaves behind a great legacy; unfortunately, Hine died in poverty in 1940.

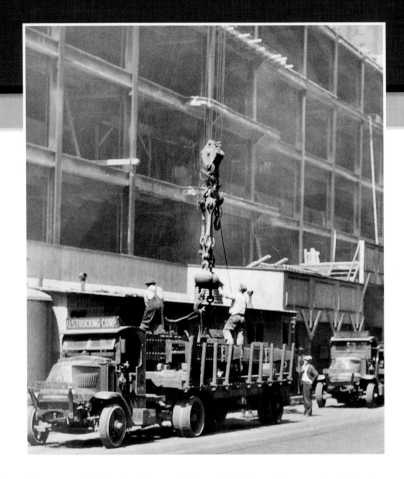

During an eight-hour day, up to 500 loads of material, not including the structural steel, were unloaded at one of the seven entrances on 33rd & 34th streets.

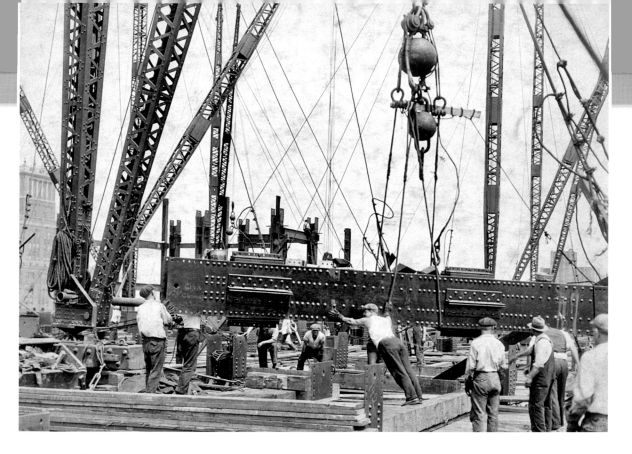

Constructed in one year and 45 days, the Empire State Building was a marvel of modern engineering. Its frame rose more than a story a day. No comparable building since has managed that rate of ascent.

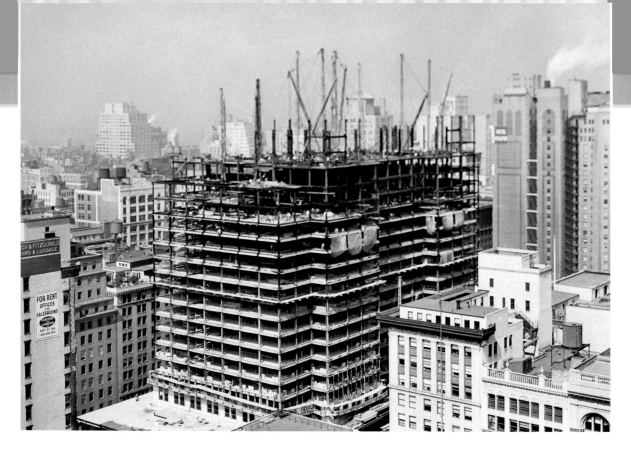

The contractors, Post and McCord, had from April to October to get the steel erected, and 80 percent was in place by August 1. It was claimed that during the month of July, 22 stories of steel were placed in 22 days–working days of regular hours. The above photo shows construction up to 16 stories.

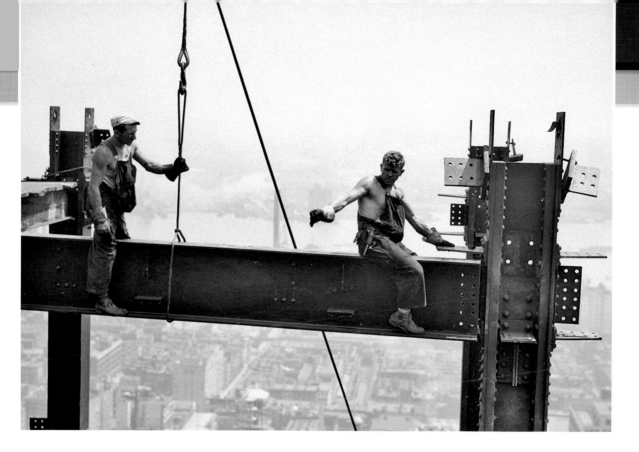

The skilled craftsmen were an integral part of the huge amount of people responsible for the construction of the Empire State Building.

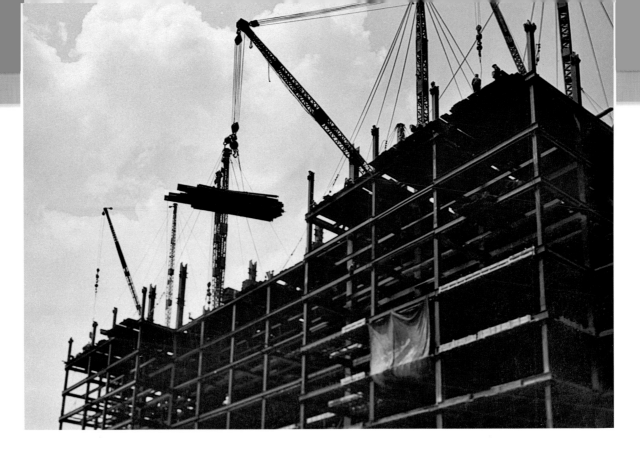

When the architect's design was approved, calls immediately went out for materials. Every order was exact and complete, specifying quantity, size, length, weight, and precise date of delivery.

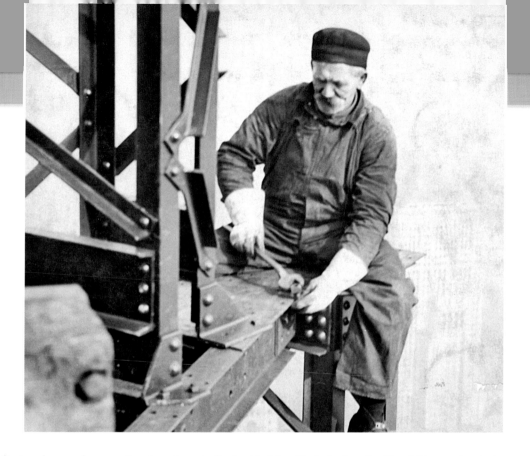

Many first and second generation immigrants flocked to New York during the Great Depression in hopes of finding work in the big city. Some of the more fortunate immigrants found work at the Empire State Building construction site.

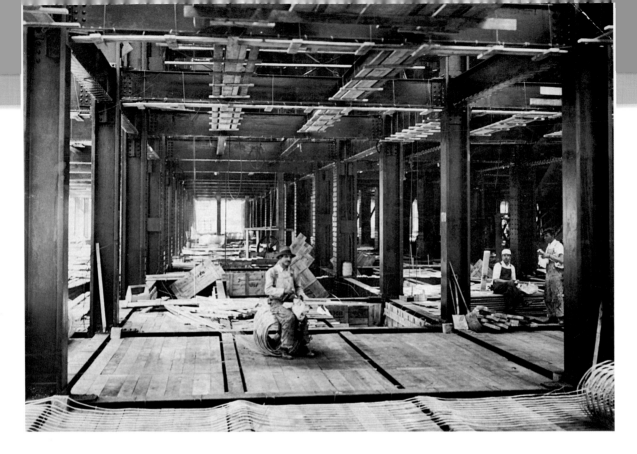

At its peak, there were 3,000 men at work at one time. Among them were 285 steel men, 107 derrick men, 290 bricklayers, 384 brick laborers, 255 carpenters, 249 elevator installers, 105 electricians, 192 plumbers, 194 heating and ventilating men, trade specialists, foremen, inspectors, checkers, clerks, and water boys.

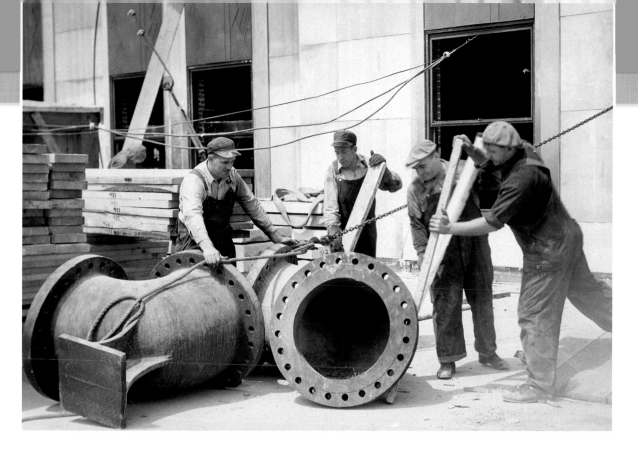

To insure the target completion date of the Empire State Building, prefabricated materials were used as much as possible. To construct the framework this included structural steel, chrome and nickel trims, steel window frames, aluminum spandrels, floor arches and outside walls. Prefabricated materials were also used in the plumbing, heating, ventilation, electrical work, elevators and many other interior finishes.

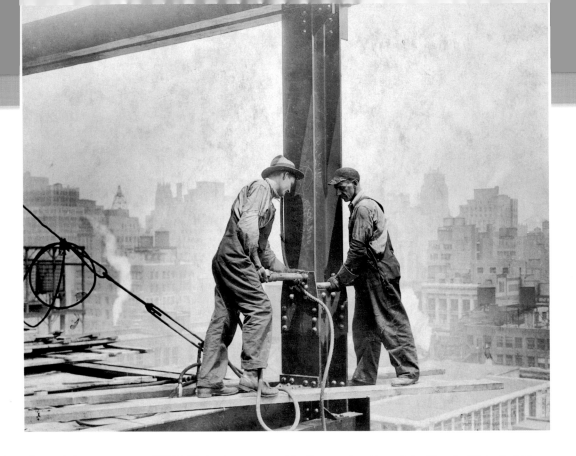

It is estimated that an excess of 200,000 rivets were used in the construction of the Empire State Building. Thirty-five to forty teams of riveters comprised of the heater, the catcher, the bucker-up, and the gunman, were employed during the construction.

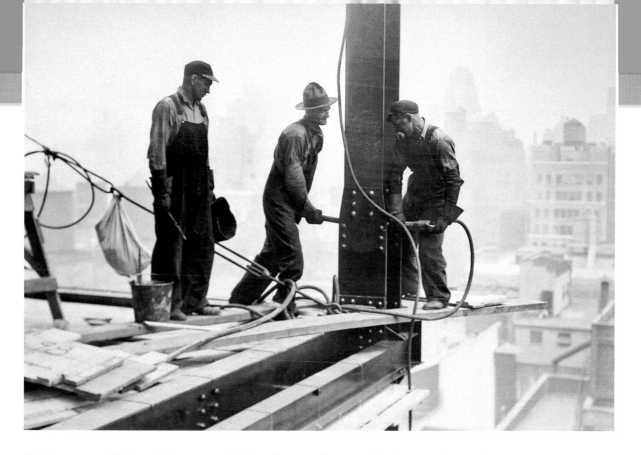

The heater would place 10 rivets into the fiery forge, and toss it, often 50 to 75 feet to the catcher. The catcher would knock it against a beam to remove any cinders, and then place the rivet into one of the holes in a beam. The bucker-up would support the rivet while the gunman would hit the head of the rivet with a riveting hammer, shoving the rivet into the girder where it would fuse together.

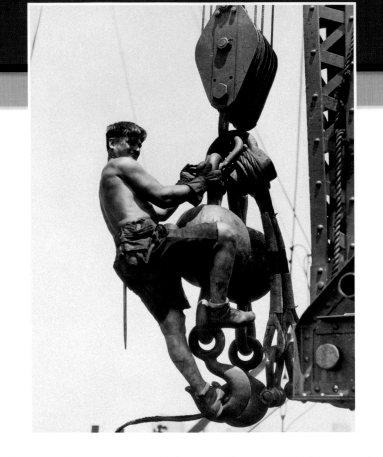

Workers would ride the hoists that were used to lift large steel beams and lift heavy machinery on the Empire State Building construction site.

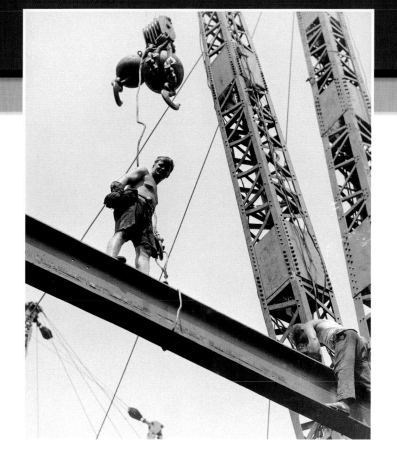

There were no government regulations in the 1930s that required the use of safety harnesses. None were used during the construction of the Empire State Building.

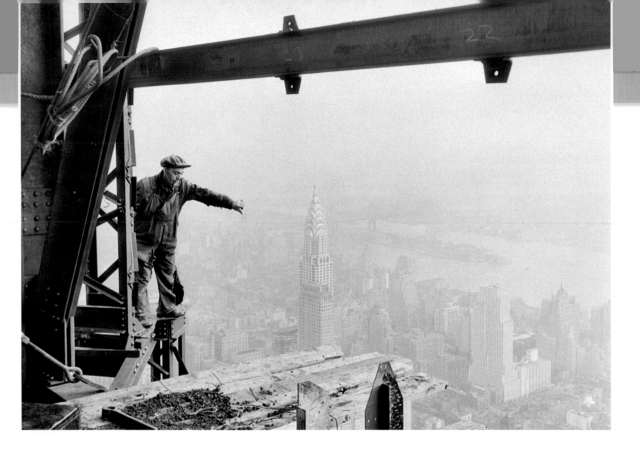

Lewis Hine's photographs documented the dangerous conditions these workers dealt with in building a modern marvel.

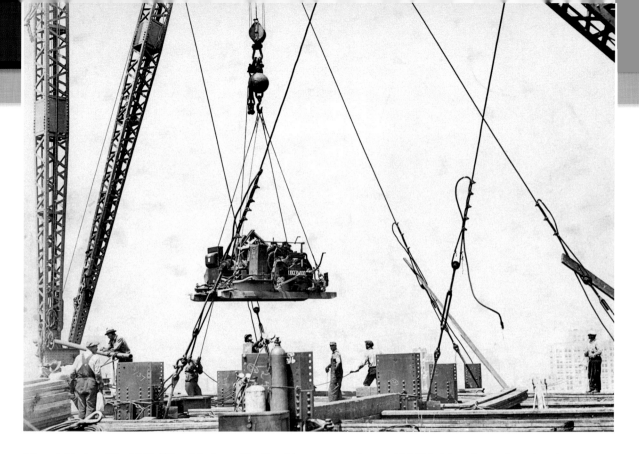

Material hoists lifted 200,000 cubic feet of Indian Limestone and over 10,000 bricks, always keeping these materials three floors ahead of where the stone setters and bricklayers were working.

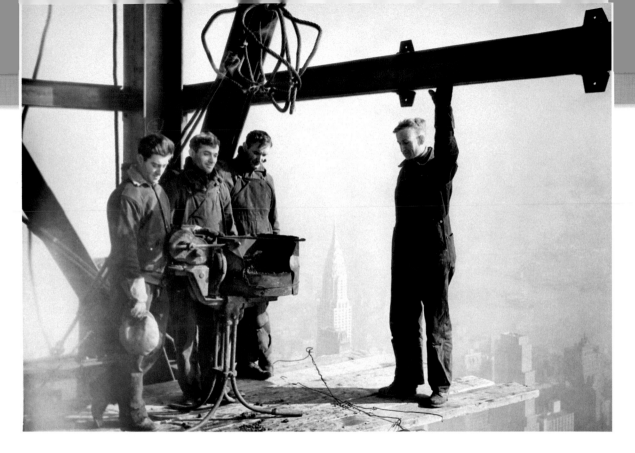

The project was completed ahead of schedule and under budget. Due to reduced costs resulting from the Depression, the final costs totalled only $24.7 million instead of the estimated $43 million.

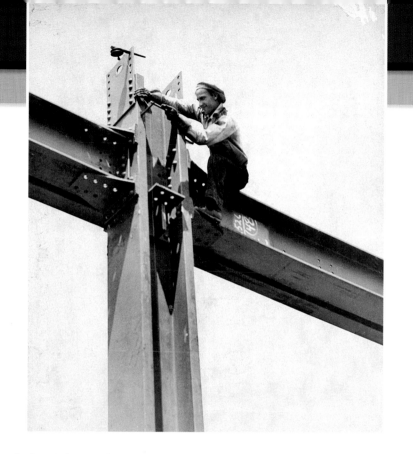

The ironworkers rode the girders as they were swung into position so they could slip bolts into place temporarily until the bolter came along and tightened them.

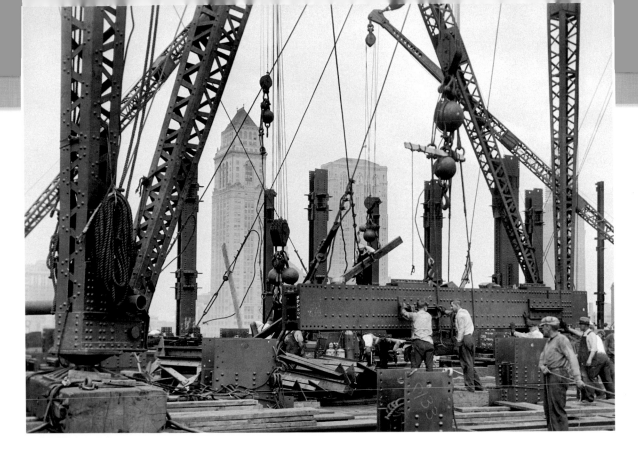

The vertical frame is made up of 210 steel columns. Twelve of these ran the entire height of the building (not including the mooring mast). Other sections ranged from six to eight stories in length. The steel girders could not be raised more than 30 stories at a time, so several large cranes (derricks) were used to pass the girders up to the higher floors.

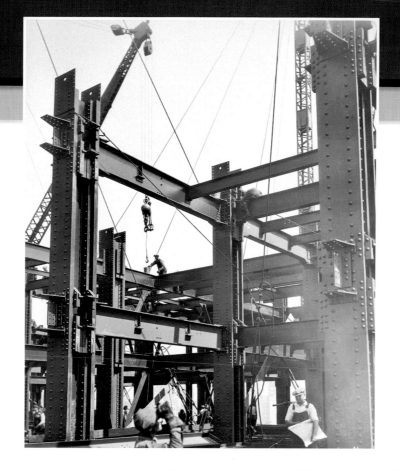

Even under the strongest wind conditions the building only moves one half inch off center. This means that measurable movement is only one half inch, or one quarter inch on each side.

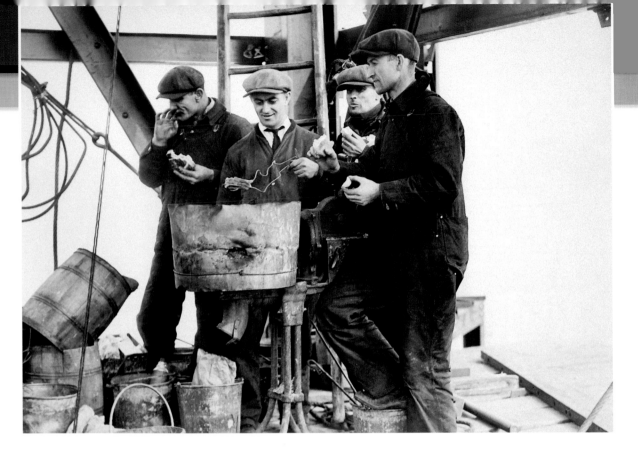

Most men brought their lunches to work. Some would use the fiery forges to warm their sandwiches. However, there were five lunch stands around the construction site owned by Lord's chain restaurant.

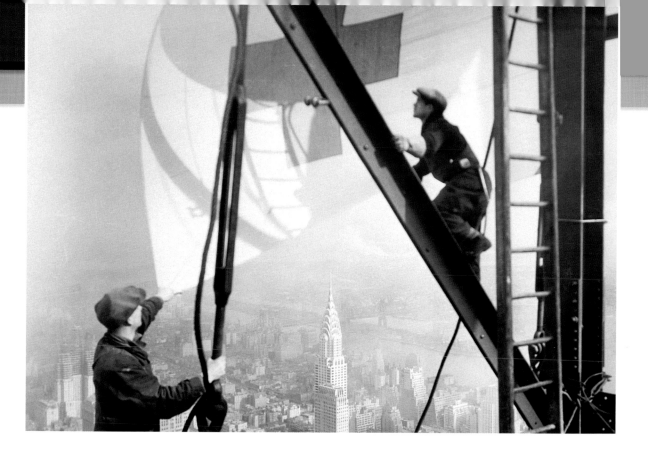

The word "skyscraper" was coined in the 1880s. By the early 1900s industry moguls raced to own the tallest building in the world. The Woolworth Building reigned from 1913-1930 at 792 feet high with 60 stories. The Bank of Manhattan was the tallest in 1930 at 927 feet high with 71 stories. Also holding the title briefly in 1930 was the Chrysler Building at 1,046 feet with 77 stories. The Empire State Building at 1,250 feet and 102 stories reigned supreme for 41 years until 1972.

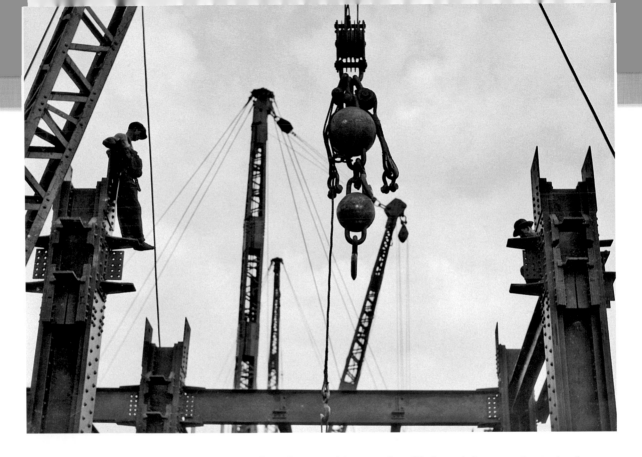

Lewis Hine enjoyed photographing man and machine working together. He hoped the emerging technology would ease the burden of hard labor.

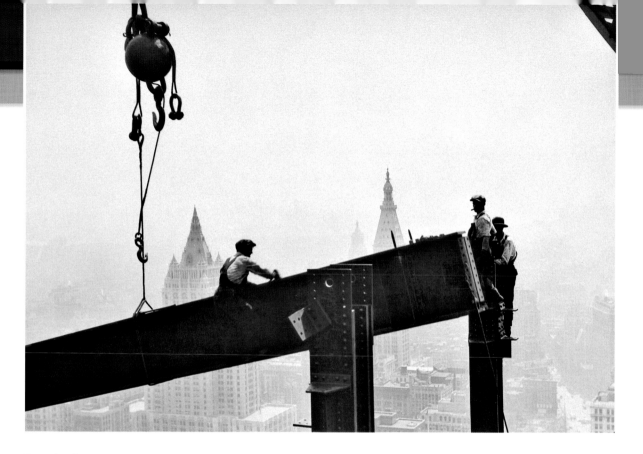

In order for Lewis Hine to obtain these photographs, he had to endure the same dangerous situations as the workers he captured.

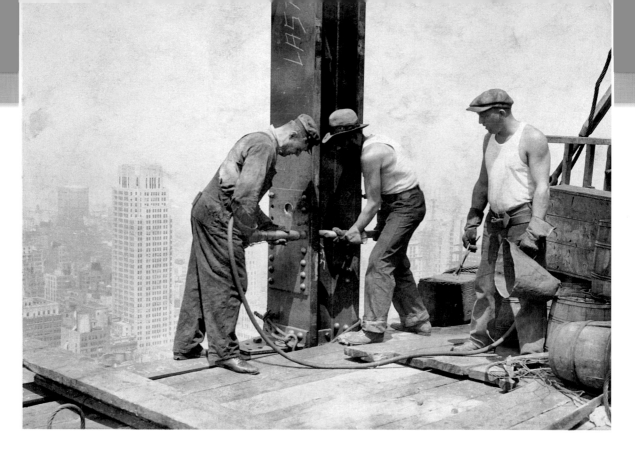

During the Great Depression one-third of Americans lived below the poverty line. The workers on the Empire State Building project earned up to $15 a day, an excellent rate of pay during those hard times.

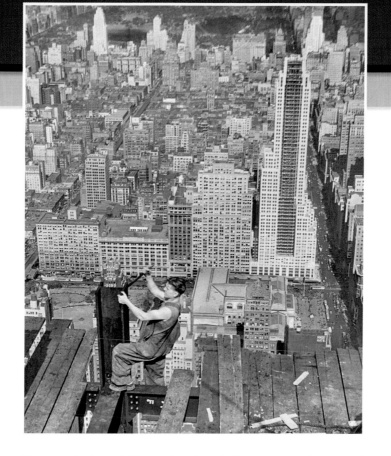

William F. Lamb, an architect at the firm of Shreve, Lamb, and Harmon, was chosen to design the Empire State Building. The clean, soaring lines were inspired by the simple design of the pencil.

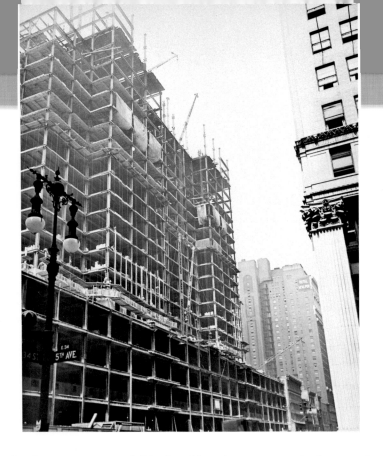

Over 62,000 cubic yards of concrete was used. The first 85 stories were completely poured on October 6, 1930, only days after the structural steel was completely set and four days ahead of schedule.

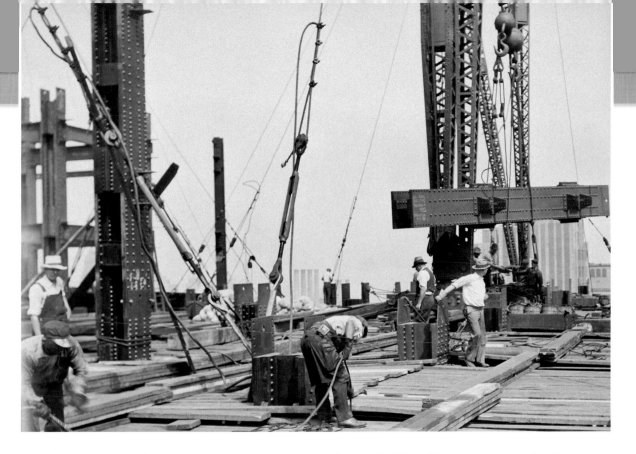

A railway was built at the construction site to move materials quickly. The railway cars were pushed by men, however the cars held eight times more than a standard wheelbarrow and they were moved with less effort.

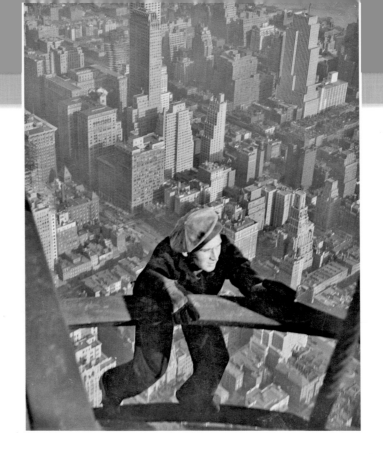

Even though he is well remembered for his work, Lewis Hine was not well paid. He died in extreme poverty November 3, 1940, shortly after the foreclosure of his home.

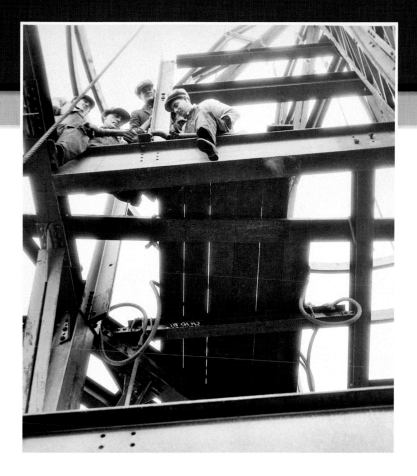

After the completion of the Empire State Building, Hine had his work featured in an exhibit at the Younkers Art Museum. *Men at Work* was published in 1932, containing photographs taken on the Empire State Building project.

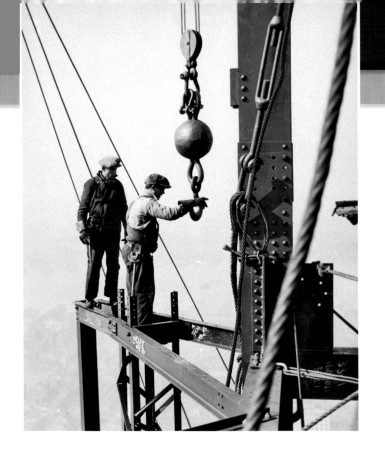

Passersby would watch with awe as the brave workers nonchalantly walked, crawled, and swung from the girders that formed what would be the tallest building in New York.

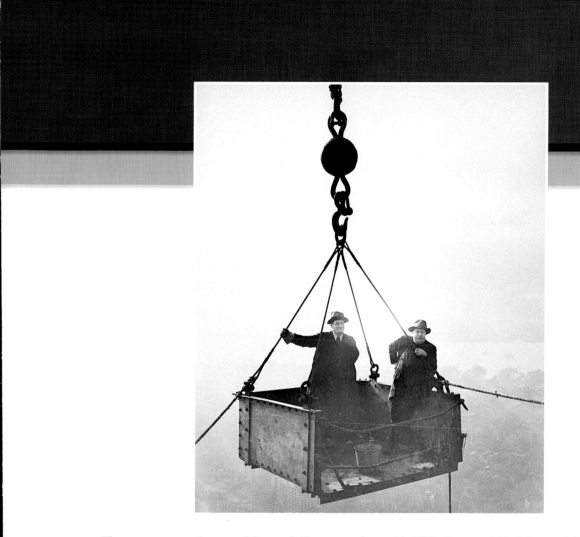

There were two mine cage lifts used. They were three-sided lifts that would hold up to 3,500 pounds.

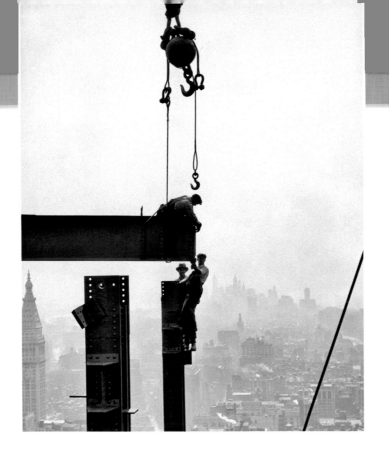

"You ain't an ironworker unless you get killed……men hurt on all jobs. Take the Washington Bridge, the Triboro Bridge. Plenty of men hurt on these jobs. Two men killed on the Hotel New Yorker. I drove rivets all the way on the job. When I got hurt I was squeezed between a crane, and a collarbone broke and all the ribs in my body, and three vertebrae. I was laid up for four years." *Chris Thorsten, a New York City ironworker.*

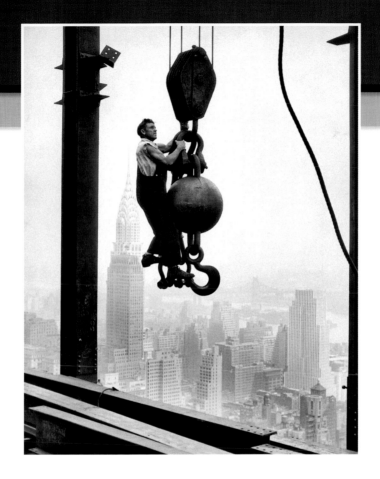

In the 19th century, Caughnawaga Indians were employed as ironworkers and developed a reputation for fearlessness and adeptness at walking on high steel.

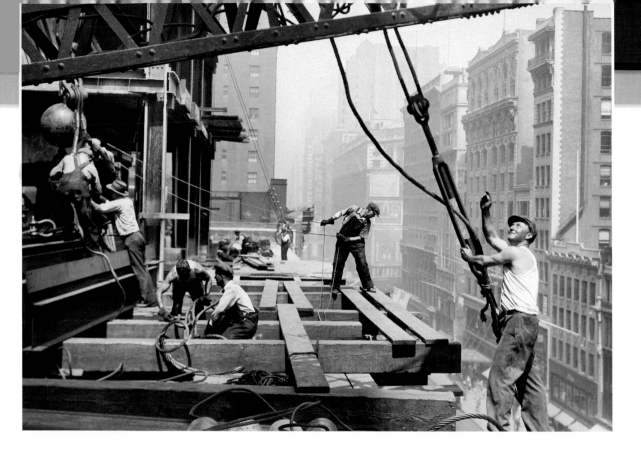

The building is 1,453 feet, 8 ⁹⁄₁₆ inches or 443.2 meters to the top of the lightning rod. The site area is 79,288 square feet or about two acres, east to west, 424 feet, north to south, 187 feet. The building foundation is 55 feet below ground; the basement is 35 feet below ground.

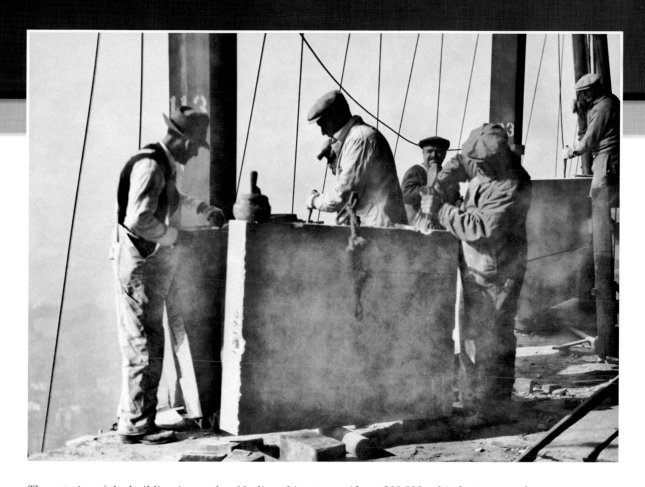

The exterior of the building is mostly of Indiana Limestone. About 200,000 cubic feet was used.

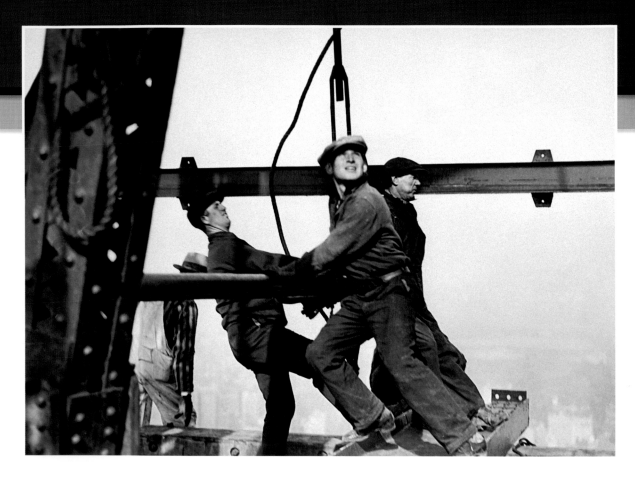

In 1905, Lewis Hine began taking photographs of poor immigrants from Europe arriving to America on Ellis Island. After taking 200 photographs he realized his calling as a photojournalist.

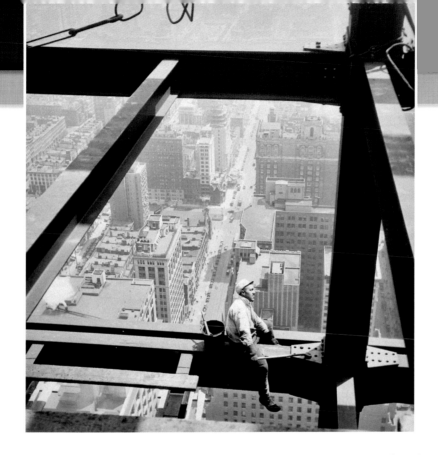

One can only wonder what thoughts these brave workers had during those moments when they were allowed to relax and take in the sights around them.

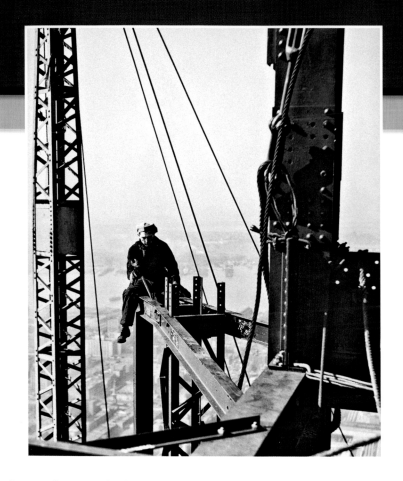

One rivet, one worker, one beam, multiplied many times over raised this monument edifice in 13 months.

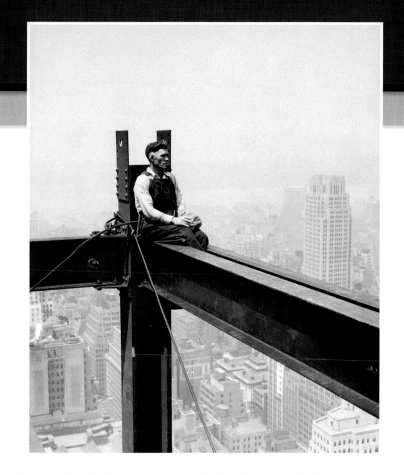

Even with 3,700 workers on the job, there were times of solitude, suspended 80 stories or more in the sky above Manhattan.

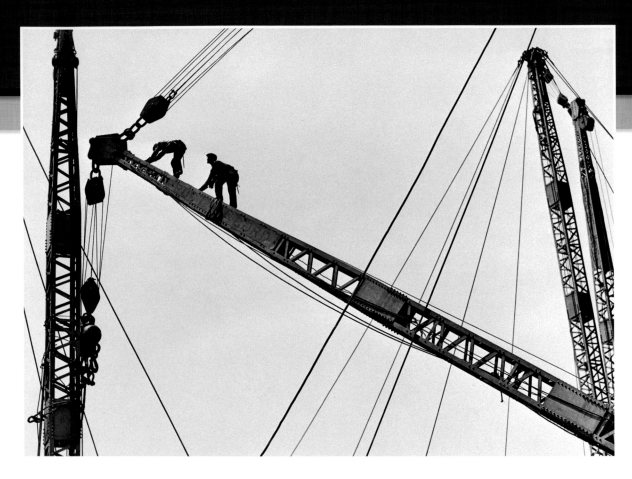

Ironworking Native Americans called themselves Skywalkers. It became a right of passage for these brave men to follow in the footsteps of their ironworking fathers.

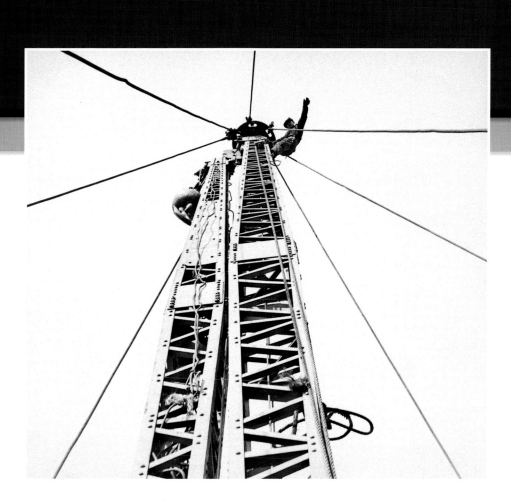

The workers celebrated as the final piece of steel was placed. A massive cheer arose from the workers when the last rivet, made of solid gold, was placed. The American flag was raised as they celebrated the achievement of the tallest building in the world.

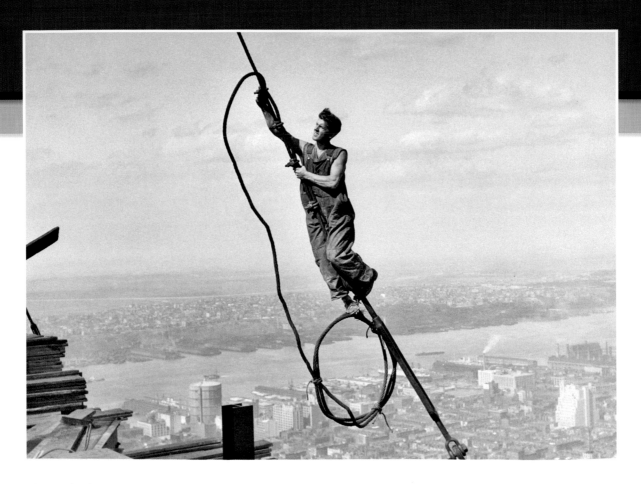

The work of Lewis Hine was an exercise in freedom of speech and of the press that made a difference in the lives of American workers. To this day the Empire State Building stands as monument to a great achievement, erecting the world's tallest building in 13 short months, a symbol of the great American can-do spirit. Hine's images have captured that spirit for generations to come.